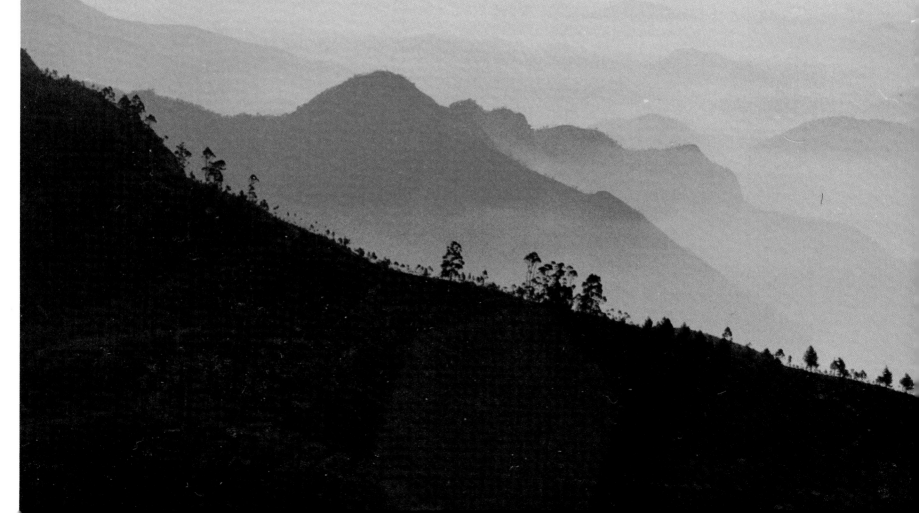

KODAIKANAL
Land of the Clouds

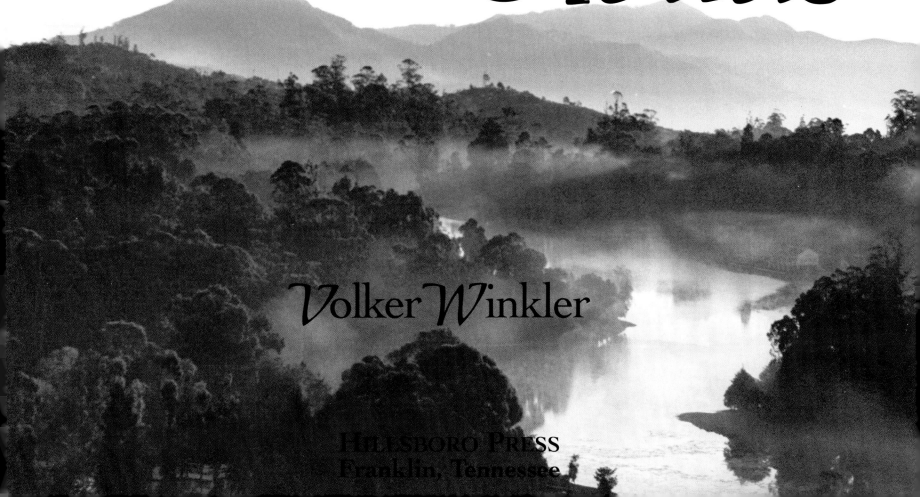

KODAIKANAL
Land of the Clouds

Volker Winkler

HILLSBORO PRESS
Franklin, Tennessee

Printed in the United States of America

03 02 01 00 99 1 2 3 4 5

Library of Congress Catalog Card Number: 98-72614

ISBN: 1-57736-102-4

Cover design by Gary Bozeman

Published by
HILLSBORO PRESS
an imprint of
PROVIDENCE HOUSE PUBLISHERS
238 Seaboard Lane • Franklin, Tennessee 37067
800-321-5692

To my wife

TINA

who was the impetus leading
to our stay in India
as well as our tour guide

and

to our six children

Kirsten, Jesse, Benjamin, Robyn, Ty,
and Roman

who embraced India with open
hearts and minds.

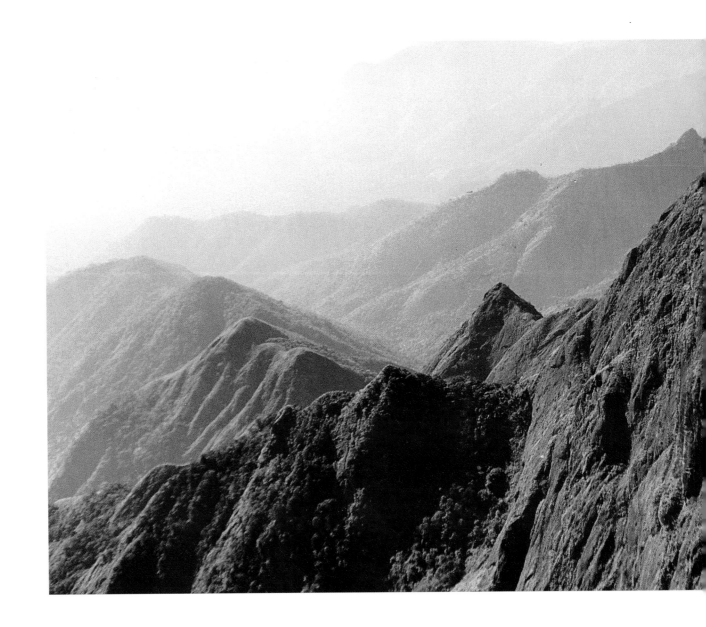

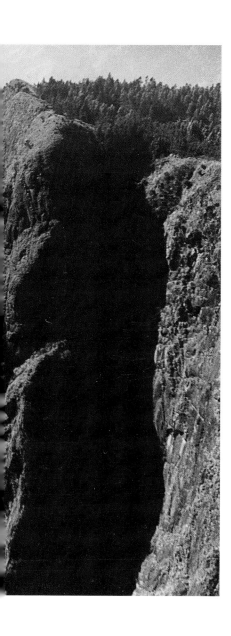

Contents

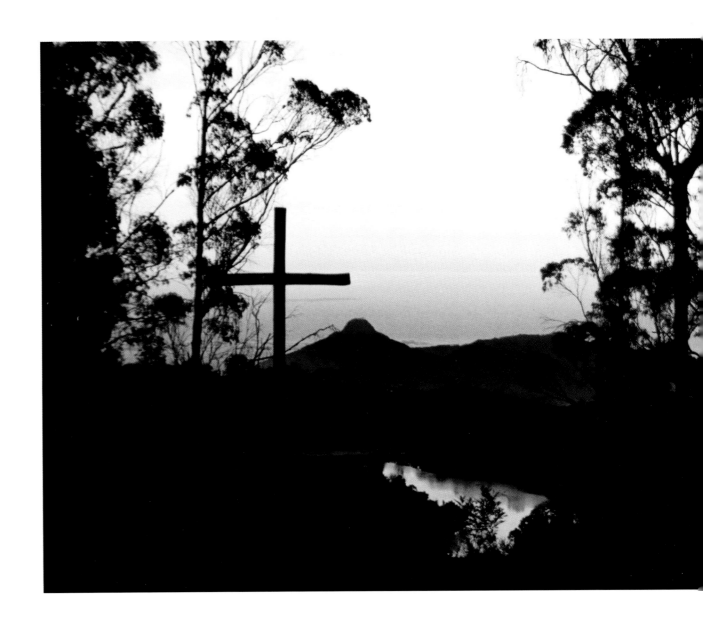

Acknowledgments

Many thanks to Gene Henning, Bruce DeJong, and Bruce Peck. By sharing your experience and knowledge of Kodai, you opened my eyes to parts of India I never would have seen on my own. The many miles of hiking trails we covered together strengthened not only our legs but also our friendship.

Thank you to Kodaikanal International School, which took us in as family. Thank you to the many residents of Kodai who shared treasured places, memories, and anecdotes, thus enriching our once-in-a-lifetime family experience.

A special thank you to all my friends and associates at the McKenzie Medical Center. When talking about my trip to India, most people have asked how I could get away from such a busy medical practice for over a year and return to a smoothly thriving practice. I thank each of you for your willingness to accept responsibility and for working hard while "the boss" was gone.

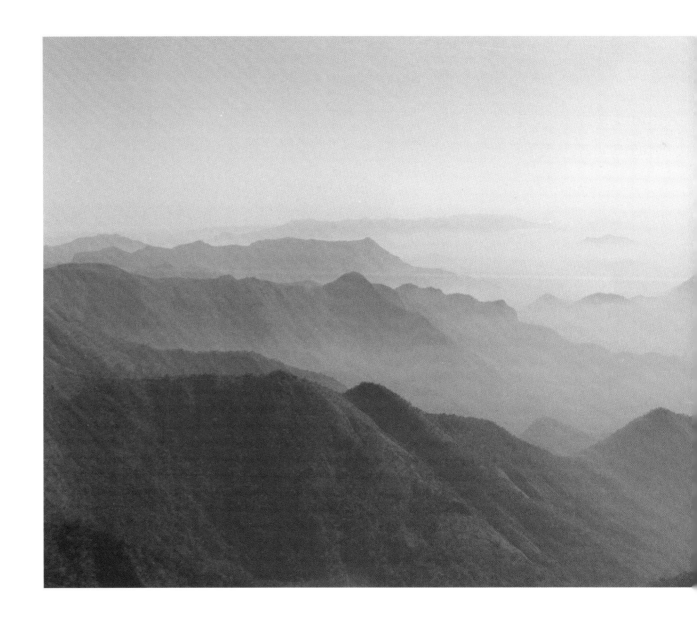

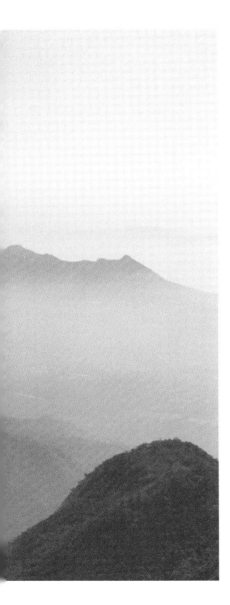

Introduction

KODAIKANAL IS INDEED A LAND IN THE CLOUDS, A MISTY AND mystical place. Situated close to the equator, Kodai is deep within the south Indian state of Tamil Nadu. Fortunately an altitude of over seven thousand feet blesses Kodai with a year-round temperate climate. The town is nestled on a plateau high above the plains. Magnificent mountain peaks arise abruptly from the flatlands below. There are no intermediate foothills—instead it is literally straight up. Thus when you look down from the mountain tops, much of southern India lies at your feet. On a clear night from Coaker's Walk, you can see the intermittent pulse of a lighthouse on an oceanside beach over sixty miles away. Because it provides such a welcome respite from the sweltering summer heat of the plains, Kodaikanal was developed as a hill station by the British in the late 1800s. In this country of ancient customs and cities, Kodai was in its infancy until it became discovered by the masses in the 1980s. Since then Kodai has entered its tumultuous (and at times irresponsible) teenage years. As are many of the world's most beautiful places, Kodai is struggling to achieve a balance between maintaining its

splendor while coping with the growing number of people who come to enjoy its beauty. Nature is very resilient to the negative influences of mankind and most of the hillsides retain their pristine beauty. Unfortunately, the ill effects of uncontrolled tourism are very much in evidence when one first arrives at Kodai. The litter, the crowds, the traffic, and the noise create doubts as to why one chose Kodai as a destination. People come to escape the hustle and bustle of India, but by coming in overwhelming numbers, they tend to bring it along. Tourism is a two-edged sword. While a boon to the local community, it also threatens to destroy the reason for coming here in the first place. Yet thankfully, Kodai can still be enjoyed now as much as it was one hundred years ago. The quiet beauty of a mountain view is heightened even more by the contrasting commotion of the Budge or Seven Roads. All the photographs that follow were made within walking distance of the town center. Sometimes it is necessary to be an early riser (or a late-night wanderer) to enjoy the tranquility of popular destinations such as Coaker's Walk. Other areas are off the beaten path. The pictures provide a taste of the splendor of this land in the clouds. While most of the locations are named, some aren't and directions aren't given. Part of the fun of getting to know Kodai is the challenge of finding places similar to these. The photographs are only a visual representation of the true beauty. You will have to use your imagination to capture the feel of the moisture on your face as clouds flow up the mountainside, to hear the waterfalls rushing in the background, to smell the fresh mountain air, and to enjoy the solitude—that sense of inner peace that isn't always associated with India and is hard to find in much of the world.

PART ONE

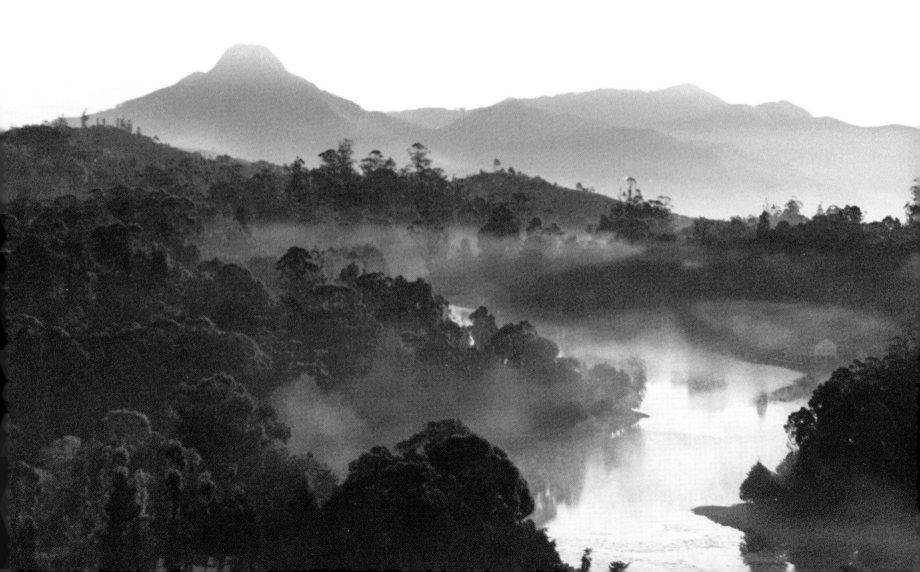

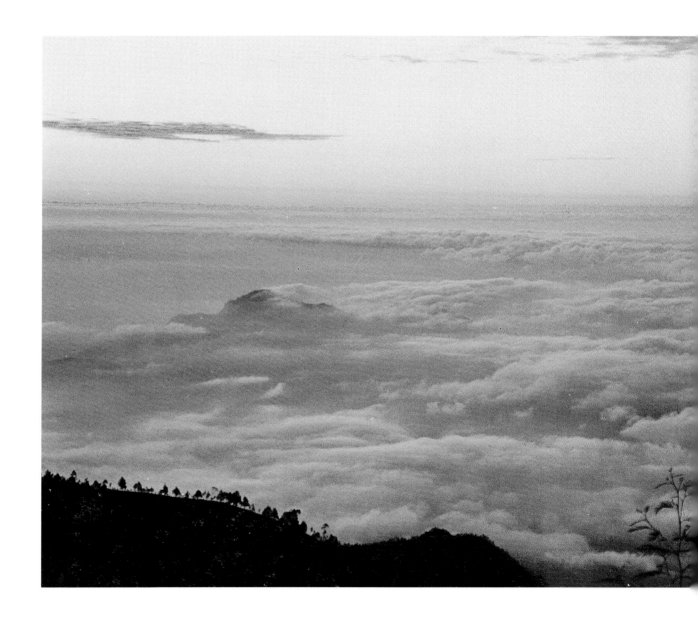

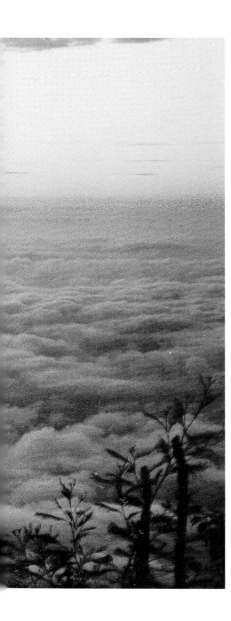

The Clouds

CLOUDS ARE AS MUCH A PART OF KODAI AS THE COOL MOUNTAIN air. There isn't a day here that does not include some form of a cloud. During the monsoons the morning skies are blue and bright while the afternoons see downpours. In the summer the plains below are covered in a hazy mist while the skies above are clear. Often the clouds insidiously sneak in, and before you know it you are walking in a dense fog. The clouds can be magnificent when you are sitting on a hilltop watching them barrel across the plains and race up the cliffs. They can also be a major frustration when you have just hiked six hours hoping to enjoy a great view, only to be rewarded with a vast sea of fog. When our family hiked to Dolphin's Nose the first time, we were completely embraced by the clouds. The children merrily ventured out onto the "Nose." On the subsequent clear-sky visit, no one would hazard to set a foot on this long, narrow precipice protruding over a drop of thousands of meters. If one is unfortunate enough to only have a few days to spend in Kodai, then clouds can be a major disappointment if they completely shroud all the views.

In Kodai, you feel a sense of harmony between the land and the clouds. On the plains, or most other places in the world, you see clouds floating high above in the sky. In Kodai you live above, below, and in the clouds. Daily you see them drifting up the cliffs or across the road. They envelop you as they roll in. You feel their moisture, not just as rain, but often as a fine layer of dew that suddenly blankets you. When flying high above the earth, who hasn't longed to reach out the airplane window to feel the enticing clouds? Kodai provides the mystical opportunity to be one with the mists.

The Town

ALTHOUGH IT IS UNKNOWN WHO FIRST ANOINTED THIS HILLTOP plateau Kodaikanal, there are several different meanings to the name. Depending on which Tamil spelling and pronunciation one uses, possible meanings include "the forest at the end (of the range of hills)," "the forest of creepers," "the forest of summer," "the forest of gifts," or finally, "the forest of umbrellas." No matter which interpretation you prefer, all are appropriate.

In the early 1800s Europeans on the plains were searching for an escape from the endless summer heat and a sanctuary from malaria, cholera, and other diseases. As in other areas of India, this led to the founding of a "hill station." The first two houses were completed in 1845. Thirteen years later the first church was built. Its roof, covered entirely by Huntly and Palmer biscuit tins, promptly collapsed under the first heavy rains. Last used in 1904, the long-neglected and overgrown cemetery is not easily found. Situated on the site of the original church, the worn gravestones bear testimony to the heavy toll on the lives of young and old during those Kodai pioneer days.

At that time, Kodai Lake was but a large swamp. It took the imagination and persistence of Sir Vere Levinge to create the centerpiece of the present town. Local villagers objected to the building of the bund, as they feared it would interfere with the water flow to their rice paddies. Sir Levinge overcame their reluctance by offering them cash wages to build the dam and guaranteeing the same wages to pull it back down again, if it jeopardized their crops. Of course, the controlled water release resulted in a multitude of benefits to the

villagers. The dam remained, creating the current Kodai Lake. The dawn mists rising off the peaceful waters of the multifingered lake are an integral part of the beauty of Kodaikanal. It would be hard to imagine Kodai without the flotilla of weekend boaters.

Much of the current charm of Kodai is also provided by the well-preserved houses and bungalows built around the lake. Hidden by lush hedges at the end of private lanes, surrounded in blooming flowers, each bearing its own name in accordance with British custom, the cottages blend in harmony with nature.

One can easily imagine walking down the street of an English village, as the cool mists envelop the area. Other tile-roofed, stone buildings are clustered in compounds bearing the national names of origin. Often only the protruding chimneys betray the presence of these well-hidden homes of the 1800s, many of which have magnificent views of the lake or of the plains far below.

The Mountains

THE SPLENDOR AND THE VERY ESSENCE OF KODAI ARE THE mountains—dominated by Perumal, the most identifiable of peaks. For hundreds of years quite bald, even Perumal has not escaped man's meddling, as it now sprouts some of those ever-present eucalyptus trees on its crown. The proud sentinel summit appears to be in dire need of a haircut. Even so, it must be one of Kodai's most recognizable landmarks.

It is well worth a predawn departure to hike down a remote path, across various hills and valleys, to reach the plains. As the altitude and rainfall

decrease, the temperature rises, resulting in a continuously changing climate. Aromatic pine, eucalyptus, and native shola trees give way to pear orchards and bamboo patches. One descends through shaded plantations of coffee, bananas, and jackfruit. Next come groves of oranges, lemons, limes, and mangoes. Interspersed are patches of head high elephant grass, fragrant lemon grass, and vines of peppercorns, until one finally arrives under the majestic coconut palms of the plains. There are numerous paths that lead to the plains and each offers a unique perspective of the mountainside. Wherever one ends up, it is not too hard to catch a bus to provide an "edge-of-the-seat" ride back up into the land of the clouds.

The Ghat Roads

GHAT, WHICH MEANS "STEP," IS AN APPROPRIATE LABEL FOR THE FOUR possible approaches to Kodai. In the 1800s the Coolie Ghat was the original footpath leading to Kodai from the plains. The journey lasted all night, and coolies carried up all the necessities of British society. The first cow that was brought up was promptly lost to a tiger, so the coolies would chant loudly to scare away tigers and to keep their courage up. Ladies were carried up on chairs suspended between poles. Carrying one particularly stout woman, the coolies improvised their customary chant with "she is like an elephant." Reaching the top, the six coolies, who had struggled under this extra burden, asked for baksheesh (a tip). They were disappointed when the woman replied in perfect Tamil "How can an elephant give baksheesh?" Apparently when they carried her down at the end of the season their chant was "She is as a feather."

Law's Ghat, by far the most common venue to Kodai, serves as a harrowing introduction to the mountains. Major Law started the bridle path

in the 1870s with orders not to have a slant greater than one in nineteen. By 1914 the road was opened, and although there have been some improvements, it probably hasn't changed much. Certainly Major Law had no inkling of the numbers of vehicles his bridle path would one day accommodate; otherwise, he might have made parts of it a little wider. Surviving the traffic, motion sickness (especially when riding in the back of one of those buses), narrow roads with outjuttings of rock, and hairpin bends makes you especially appreciate your final destination.

From the north, Palni Ghat is a much more leisurely approach with probably even more spectacular views, as well as more hairpin turns. Seldom-used Thandi Ghat joins up with Law's Ghat halfway up the mountain. This route provides a tour of native villages and extensive coffee plantations.

A fifth approach is a four-wheel-drive route via the west through Munar. This is also referred to as the Jungle Road, and rightfully so. After leaving the tea plantations of Top Station behind, one has a great sense of jungle and very little sense of road. Striking out through lush untouched forests, it is not unusual to come across wild elephants, gaur, and monkeys. The cliffs are breathtaking and the waterfalls picturesque, but it's not a recommended approach to Kodai for the usual tourist car, as "road" is an exaggeration. The holes, boulders, and stream fords challenge the best of four-wheel-drive vehicles.

The Tourists

No description of Kodai would be complete without a mention of the tourists. It is unfortunate that the very attractive qualities

of the area also make it vulnerable to a large influx of people. A mere fifteen years ago the Ghat saw three buses a day. Now there are over three an hour. The fragile environment and limited resources of the area are ill-equipped to deal with the sheer numbers of visitors. Ironically, although many locals pine for the days gone by, they profit handsomely from the changes.

The noise, litter, and pollution provide a challenge to visitors and residents alike. Other popular worldwide destinations see many more tourists and yet don't have near the litter—so there are solutions. For the current visitors and residents, it becomes an exercise in ingenuity to avoid the crowds. Coaker's Walk is equally impressive in the moonlight. Pillar Rocks at sunrise is as quiet as it ever was. Hiking trails abound and, thankfully, most tourists are no keener about extended walking than getting out of bed early. So Kodai can be enjoyed as much as ever.

Kodai International School

CONSIDERING ITS SIZE, KODAI HAS AN UNCOMMONLY LARGE NUMBER of schools. Exemplary Kodai International School is not only the jewel of them all, but also played a significant role in Kodai's development. Symbolic of its role in the community, the school entrance is one of the seven roads of the Seven Road junction. Founded in 1901 by an American for the children of missionaries, the original class was thirteen pupils. No longer limited to missionary offspring, the dorms now house a student body of over five hundred. Half of the pupils are Indian, and the rest represent fifty countries, thus making it a truly international academy—a unique school with its students representing a unique microcosm of the

world. Striking stone buildings, connected by quaint walkways and embraced by lush plants and blooming flowers, compose the twenty-acre campus overlooking Kodai Lake. Curriculum emphasizes independent thinking and learning, while nurturing a sensitivity to India and the threatened local environment. Education of the person as a whole includes standard subjects as well as a variety of others from drama to physical education, art to hiking, and music to week- long field trips. The students' conduct is guided by rules, stretching like a tightrope between the expectations of different cultures. Balancing between the permissiveness of the West and the structured East, pupils emerge with an understanding of cultures difficult to appreciate in most other schools of the world. The high academic standards give graduates their choice of universities worldwide.

Over the years, the school has played a foundational role in Kodai's development. Long before tourism became a driving economic force, the school was a mainstay for local employment. The school either owns or administers many of the bungalows and larger properties surrounding the lake. Thus, central Kodai has been preserved and protected from overdevelopment. The established presence of the school has served as a continuum from the time of the first missionaries to the present.

The Land of the Clouds

In a country filled with beauty, Kodaikanal stands out as one of the more magnificent places. As all of India, it is an area of contrasts. Often the bad alongside the good only serves to accentuate the splendor. Some of the "in-between" causes a disbelieving shake of the

head or an involuntary laugh aloud. The nighttime silence around the lake is shattered at dawn by water lorries belching diesel fumes and blasting Tamil music as their hoses snake into the water drinking thirstily. Parked on opposite sides of the lake two lorries play dueling air horns providing a "gentle" wake-up call to local residents. The rising of the lake's mists reveals a fisherman patiently retrieving his nets with the catch of the day. The sun rises over Coaker's Walk, providing a daily delight that is as unique as each new day. The Muslim call to prayer provides the accompaniment to this dazzling display of color on the clouds. Far below life awakens on the plains that stretch to the distant horizon. During the day the commotion of the town can be left behind with a fifteen-minute walk. One has a tranquil picnic on top of the world with a panorama of hills, cliffs, singing birds, lush vegetation, solitude, peace, and yes, clouds. As evening approaches, barefooted women, balancing long loads of wood on their heads, gracefully thread their way down the hillsides. A final night's stroll along Coaker's brings one even closer to the thousands of stars twinkling above. The lights on the plains below sparkle like handfuls of diamonds strewn as far as the eye can see. Kodaikanal will always have a special place in the hearts of all those who experience its beauty.

PART TWO

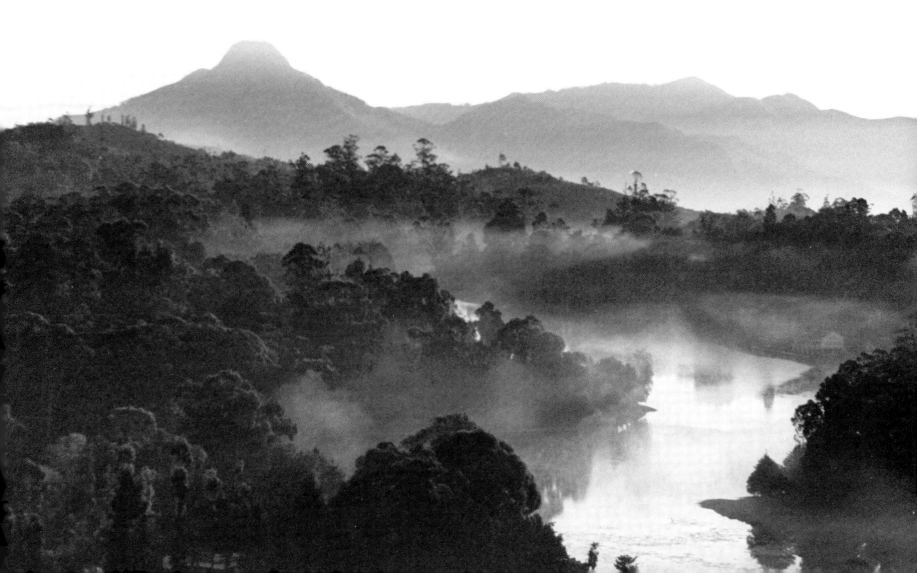

THE PHOTOGRAPHS

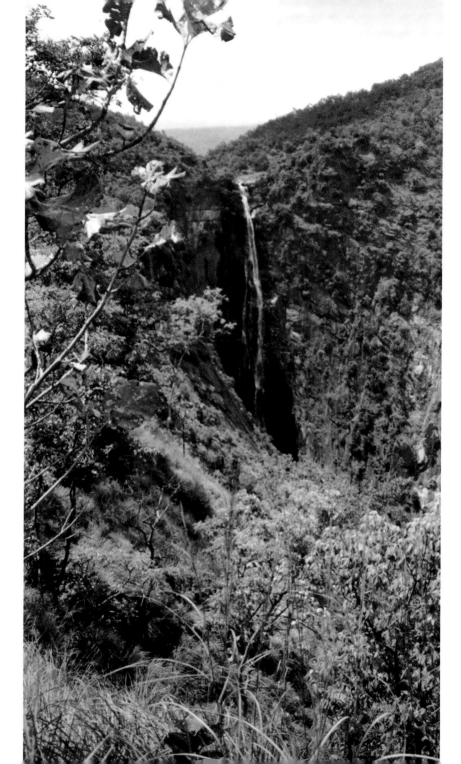

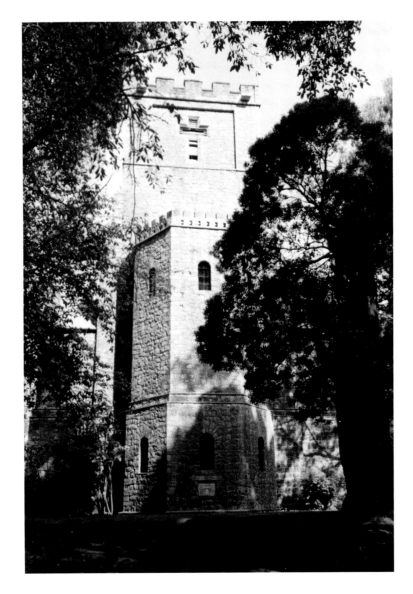

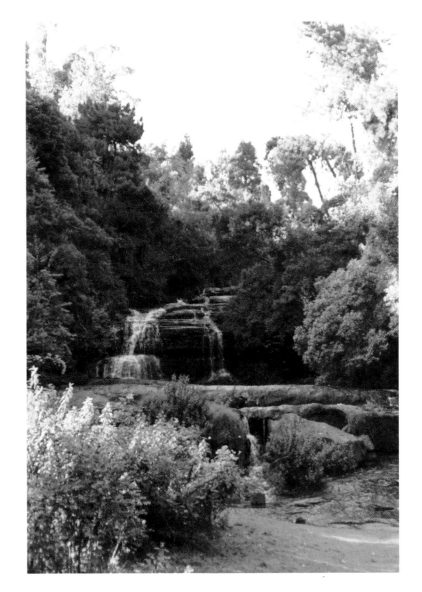

16

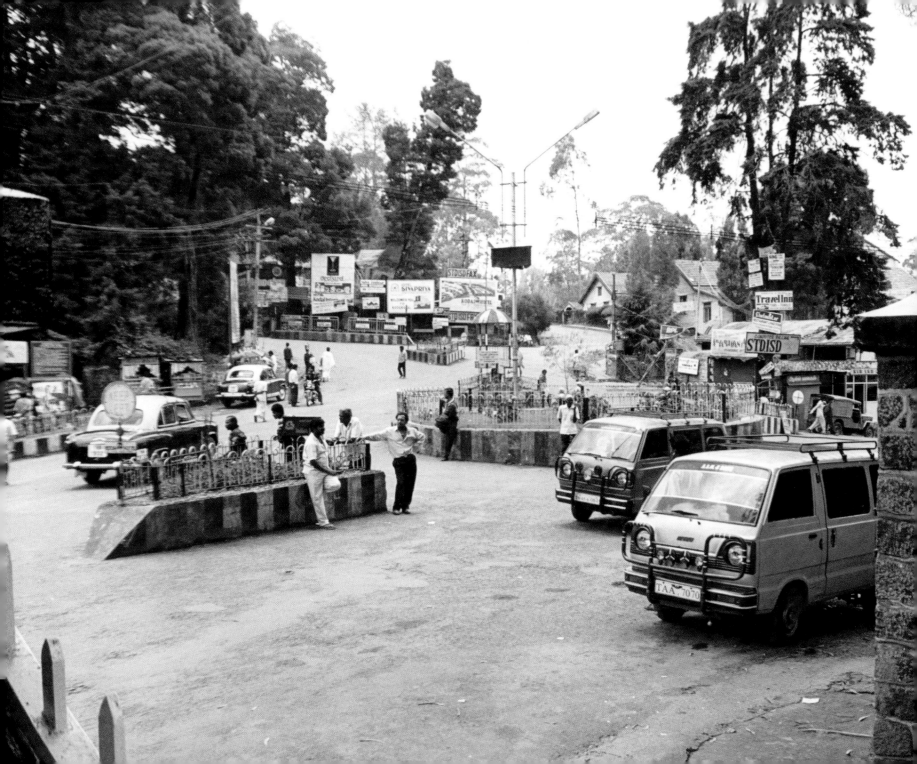

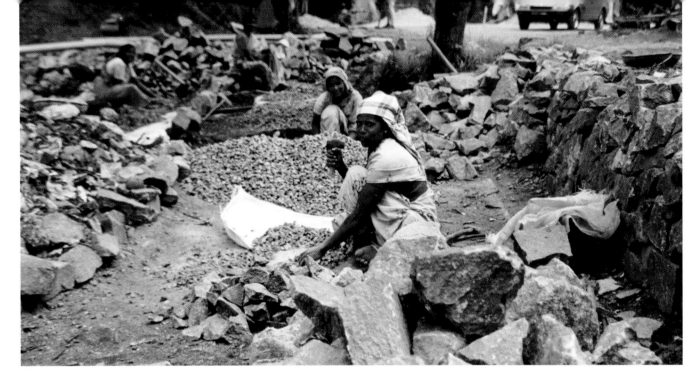

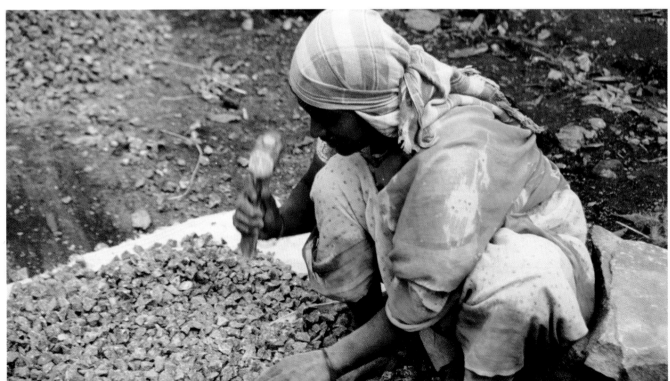

18

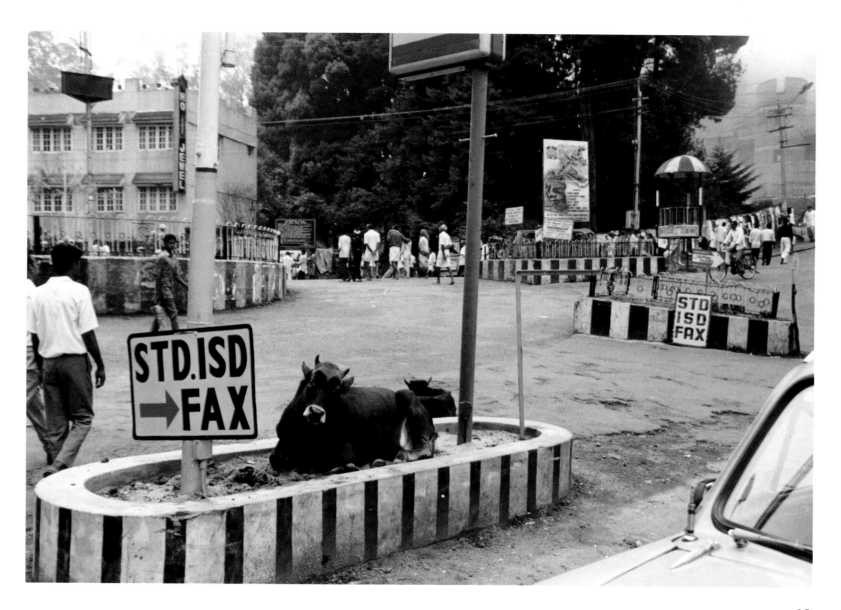

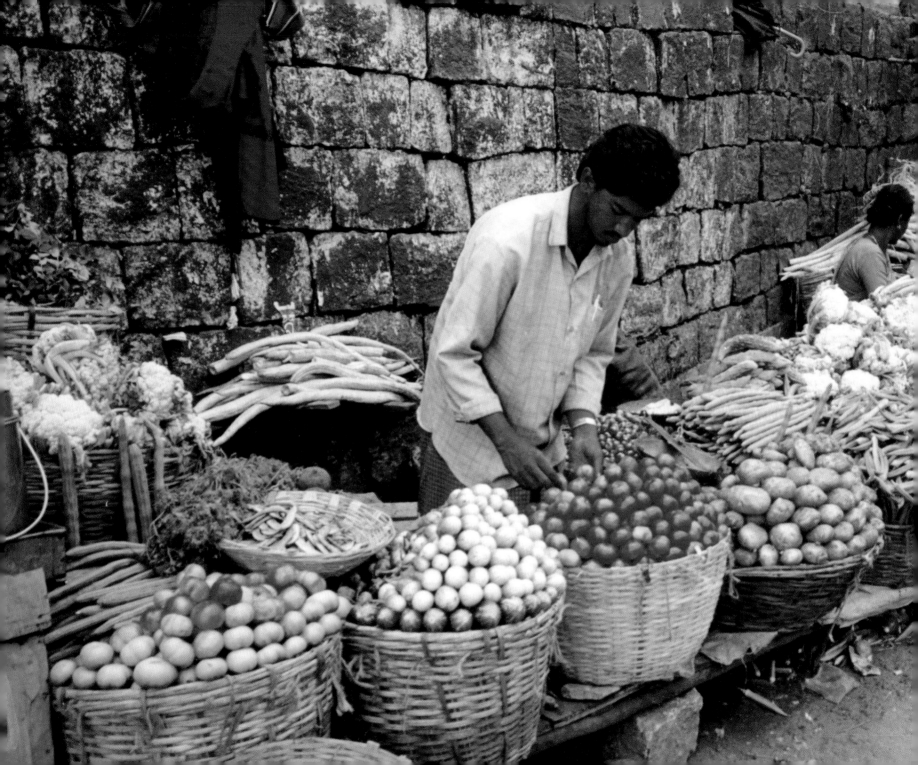

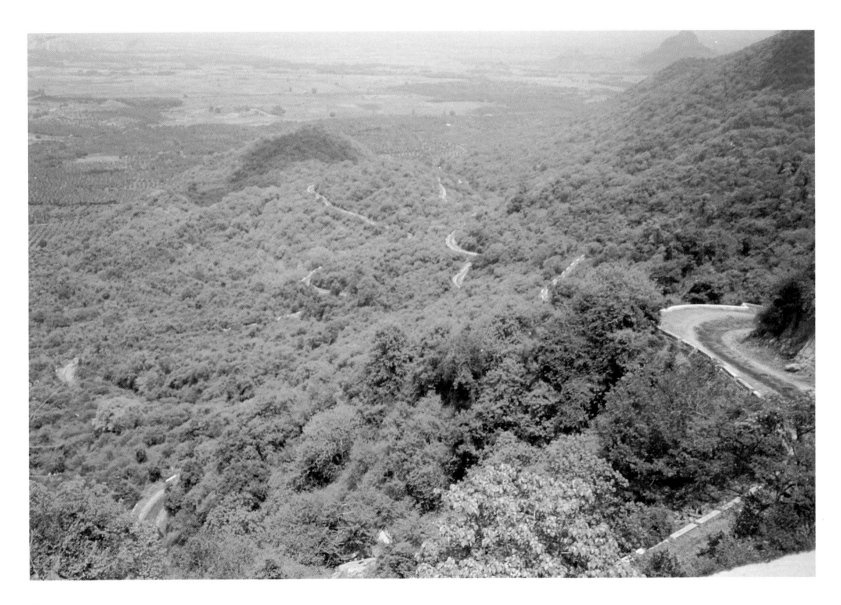

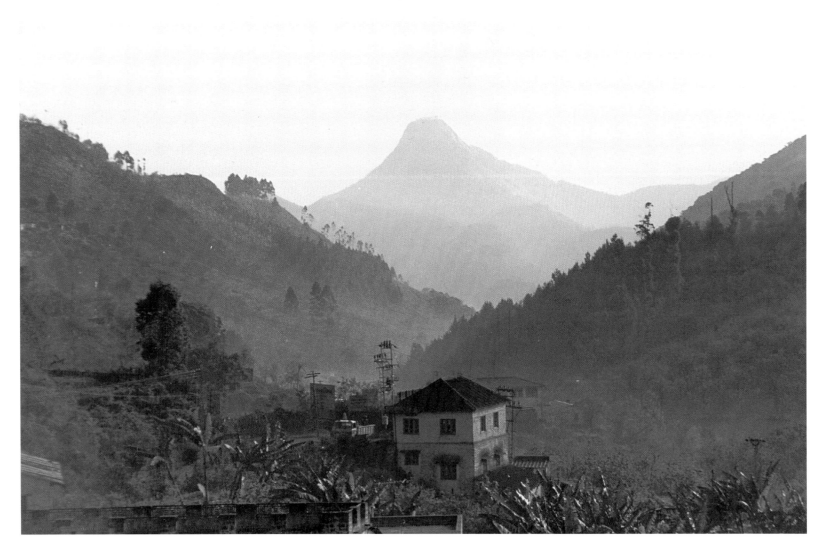

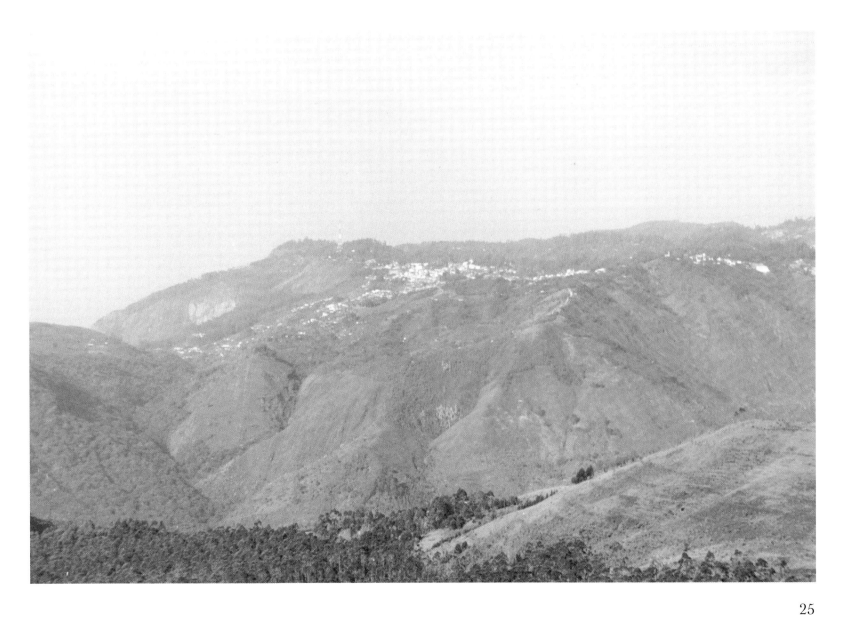

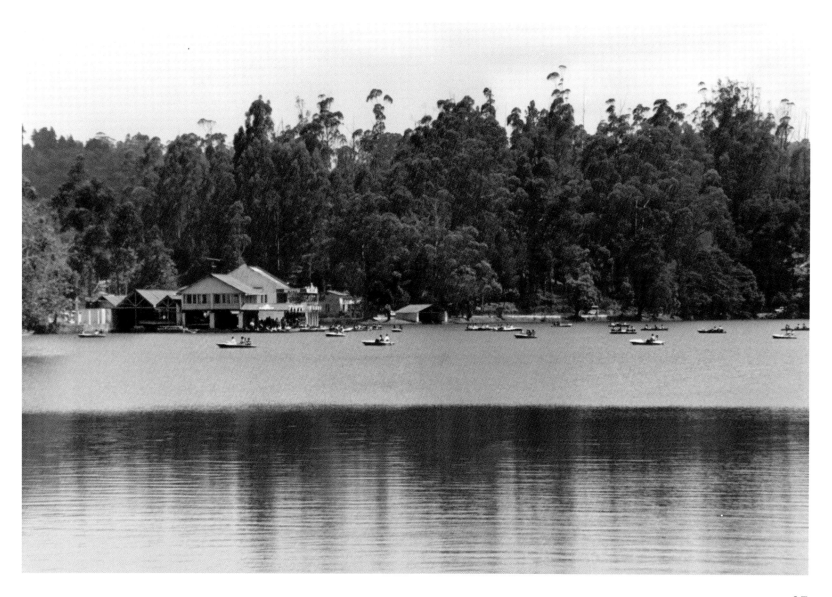

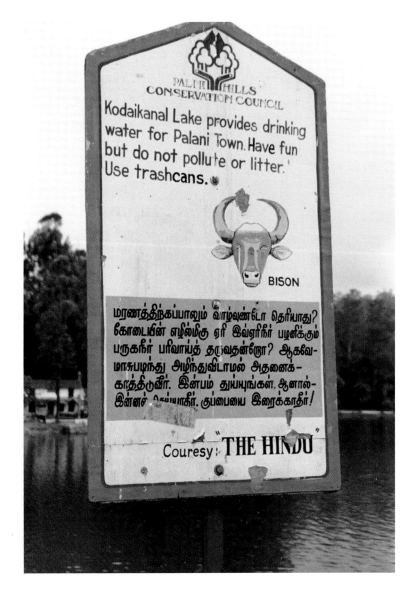

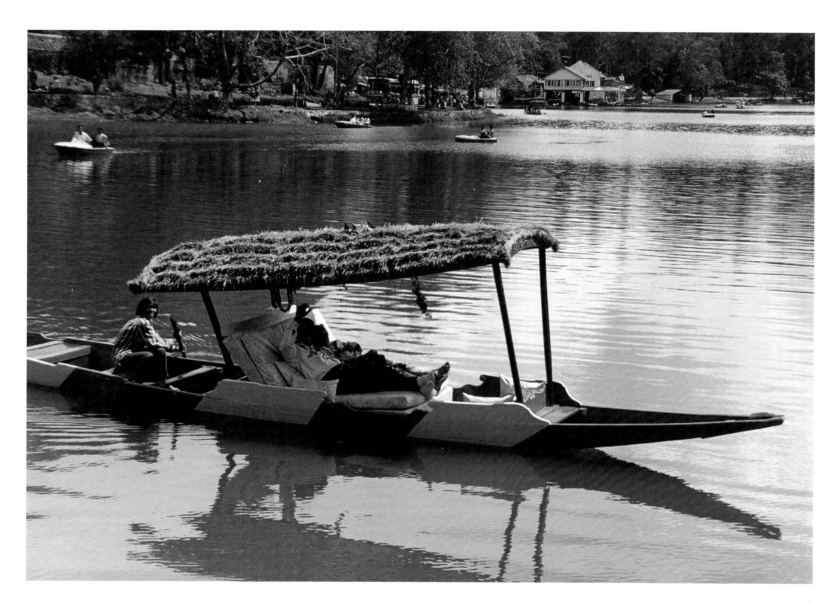

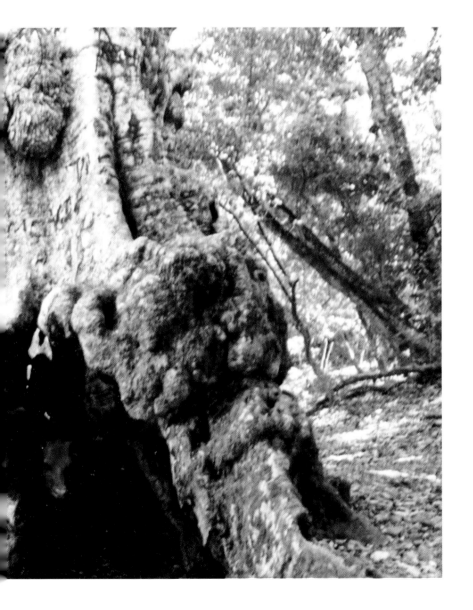

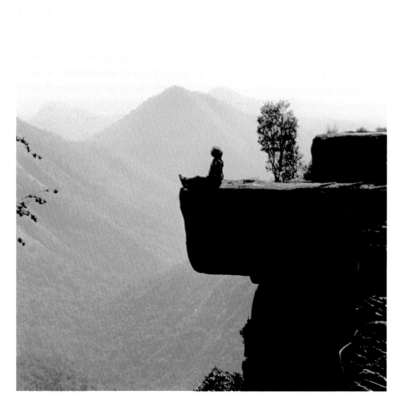

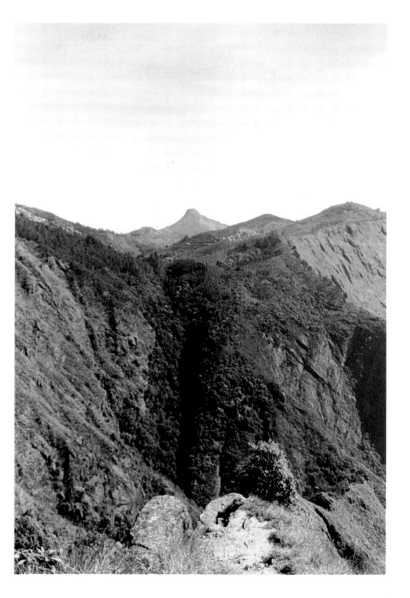

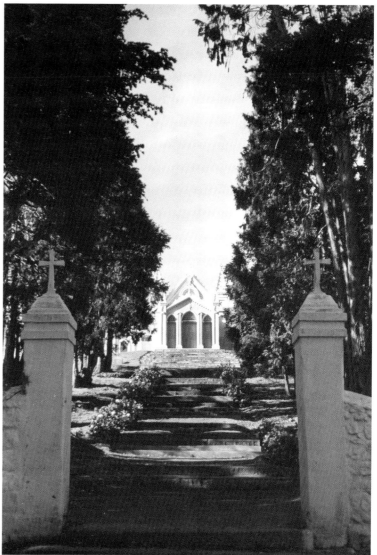

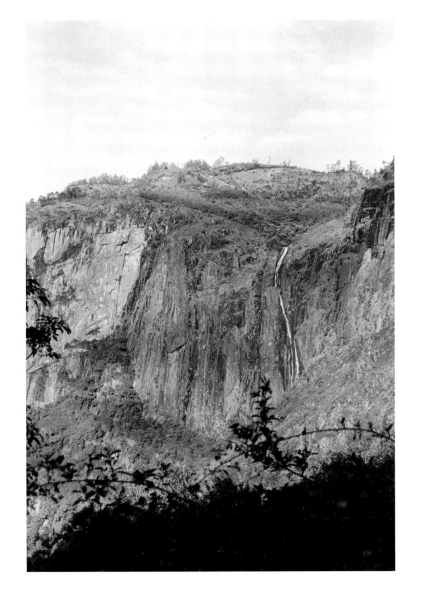

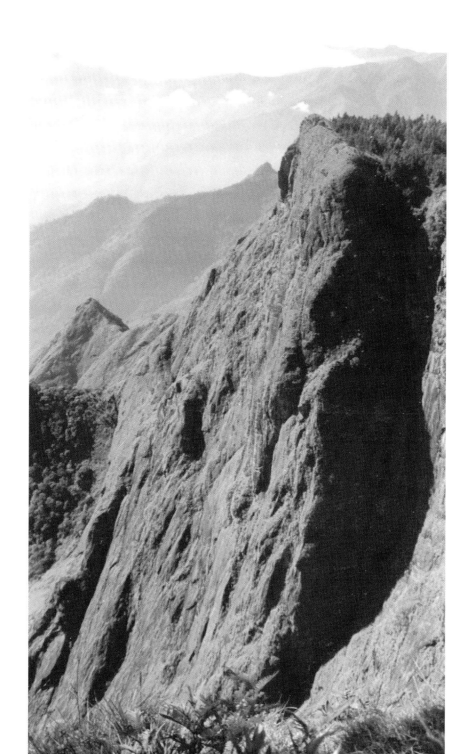

37

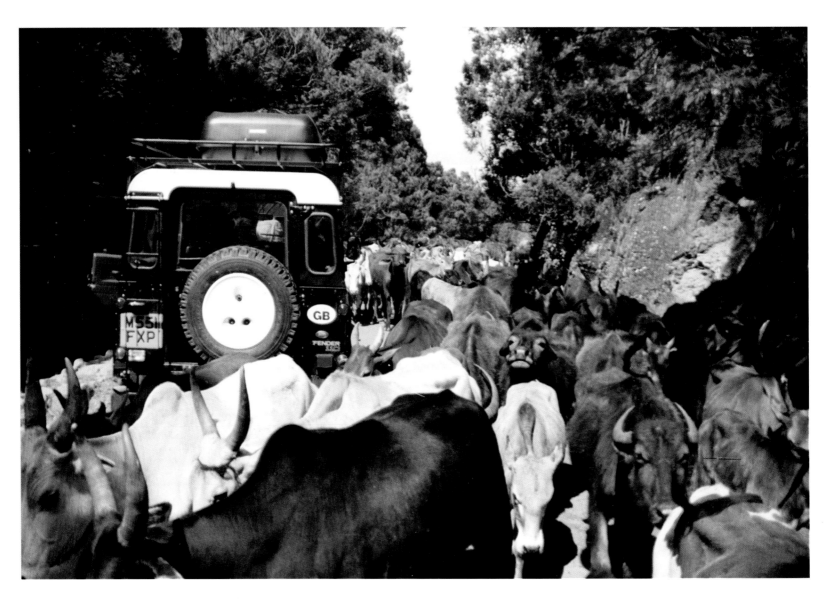

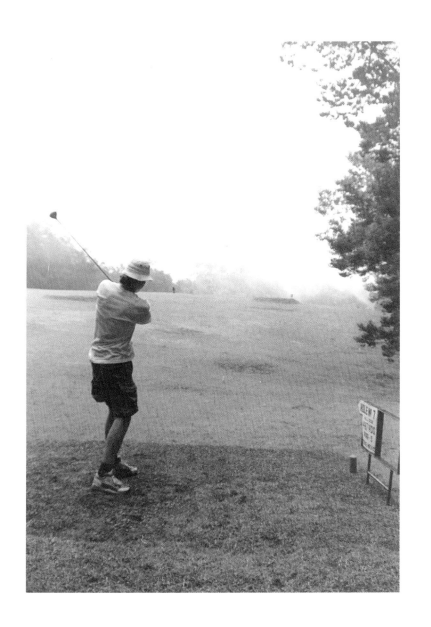

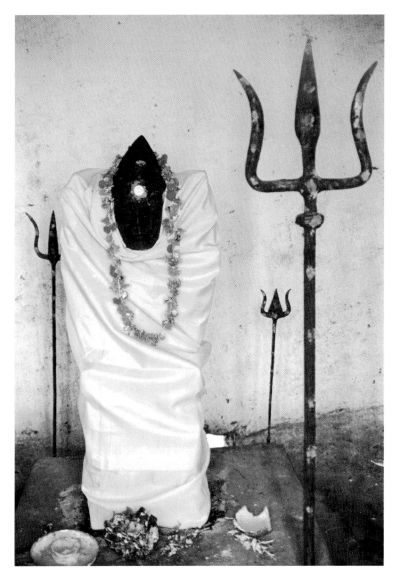

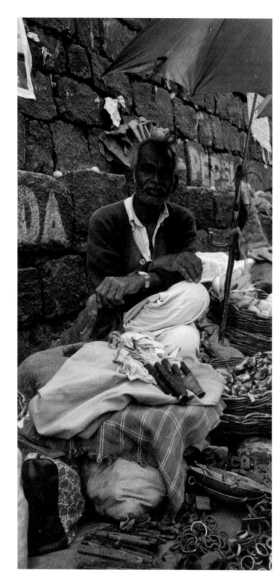

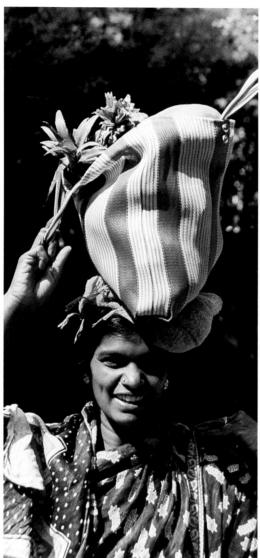

Tourists are ambassadors of their states. Have fun but do not jeer and wave at passersby.

IBEX

யாத்திரீகர்கள்தான் ஒரு நாட்டின் தூதுவர்கள்!
இம்மலையில் வேடிக்கையாய்ப் பொழுதுபோக்குங்கள் –
ஆனால் போவோர் வருவோரைப் பார்த்துள்ளிங்கையாழியும்
கின்டல்செய்வதை தவிர்த்திடுவீர். அழகையெல்லாம் பம்பித்துச்
செல்லும் நீங்கள் பாதச்சுவருதவிர்வேறுளதையும் விட்டச்செல்லாதீர்!

Courtesy! "SAVORIT"
UNITED INDIA FOODS

GOLD SPOT

T.T.D.C. COOL BAR

PRESERVE THIS BEAUTY IN WILDERNESS.

TAMIL NADU
FOREST DEPARTMENT

43

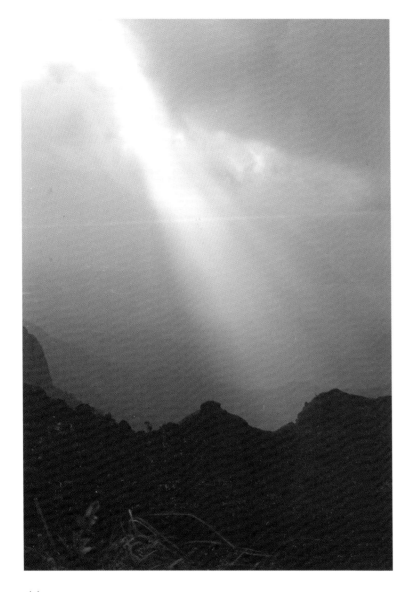

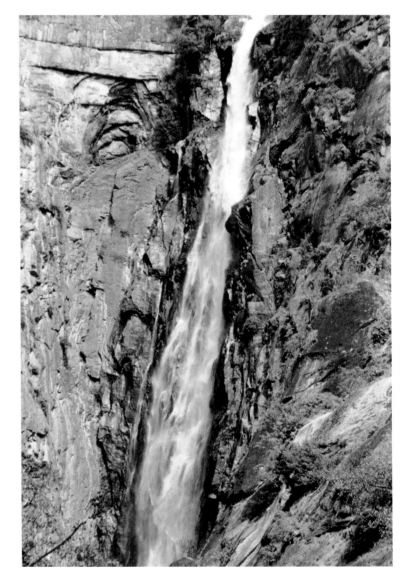

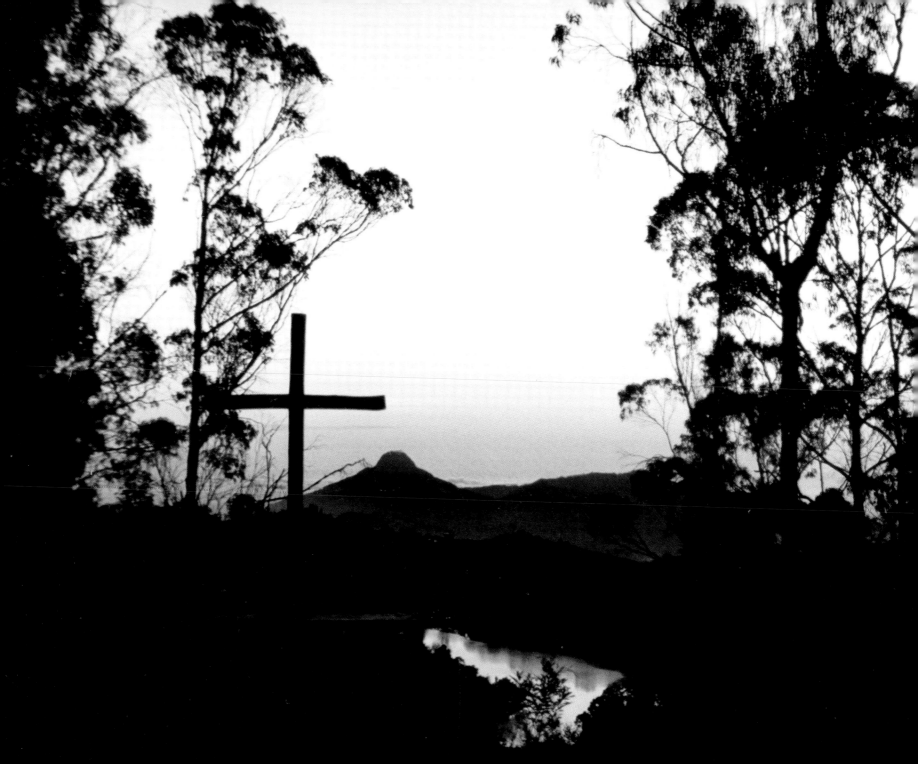

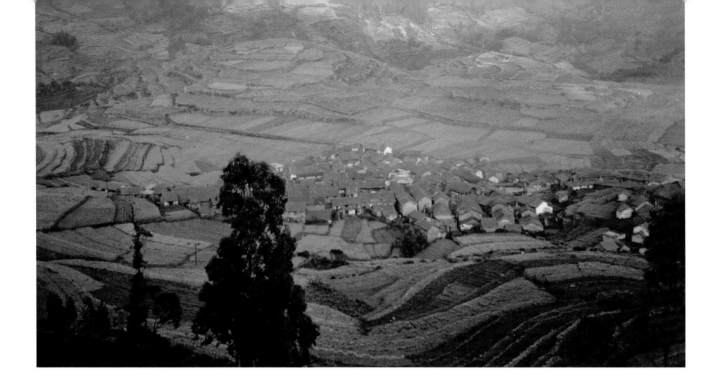

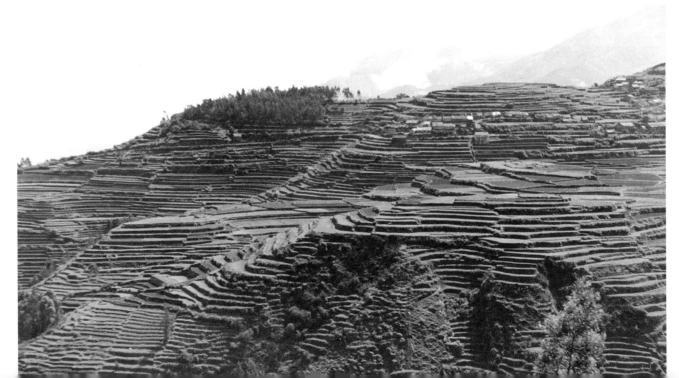

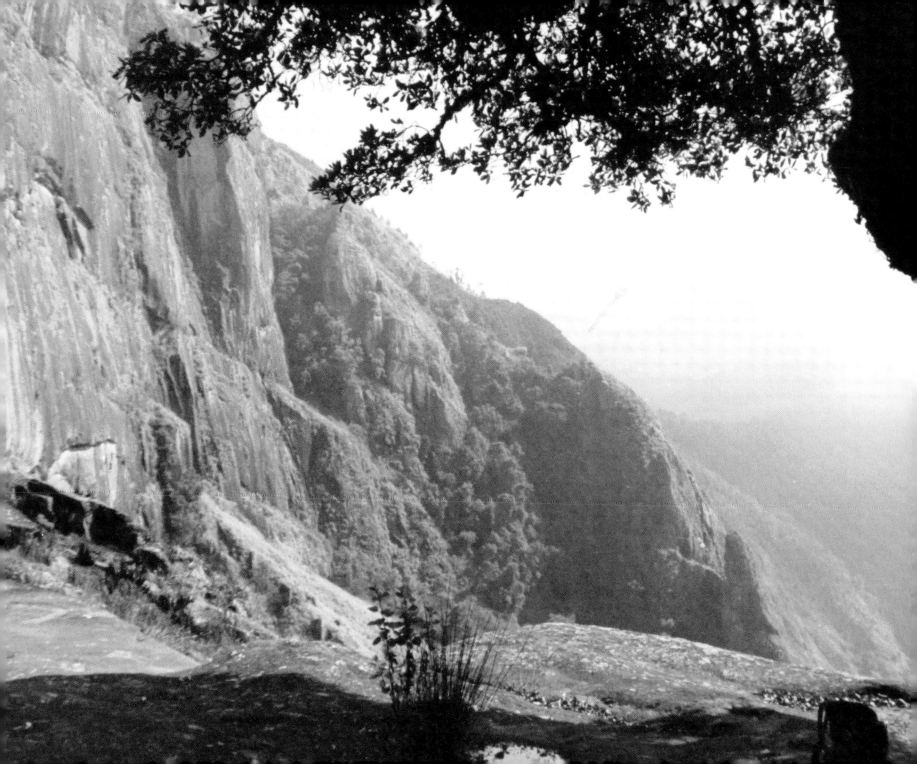

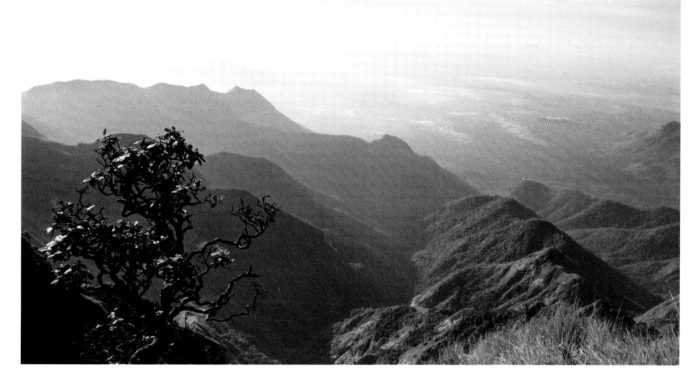

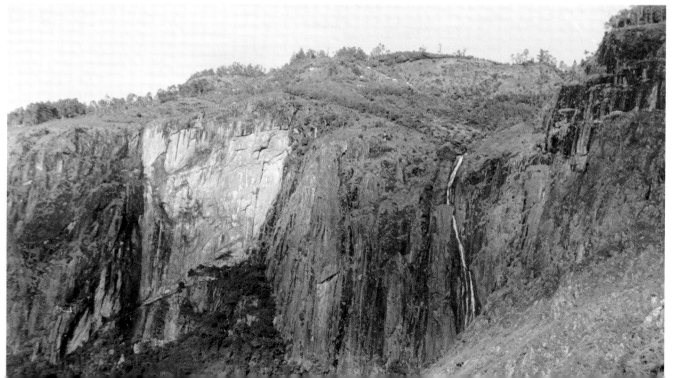

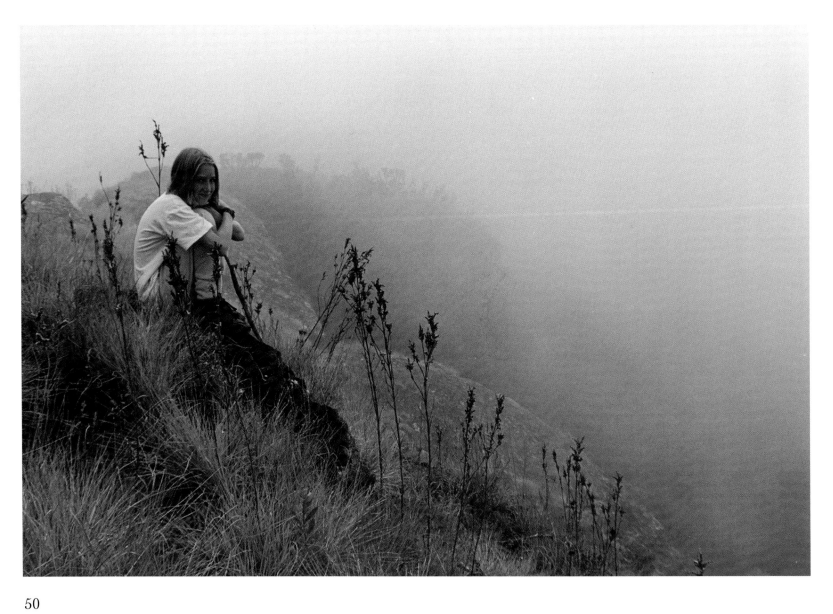

50

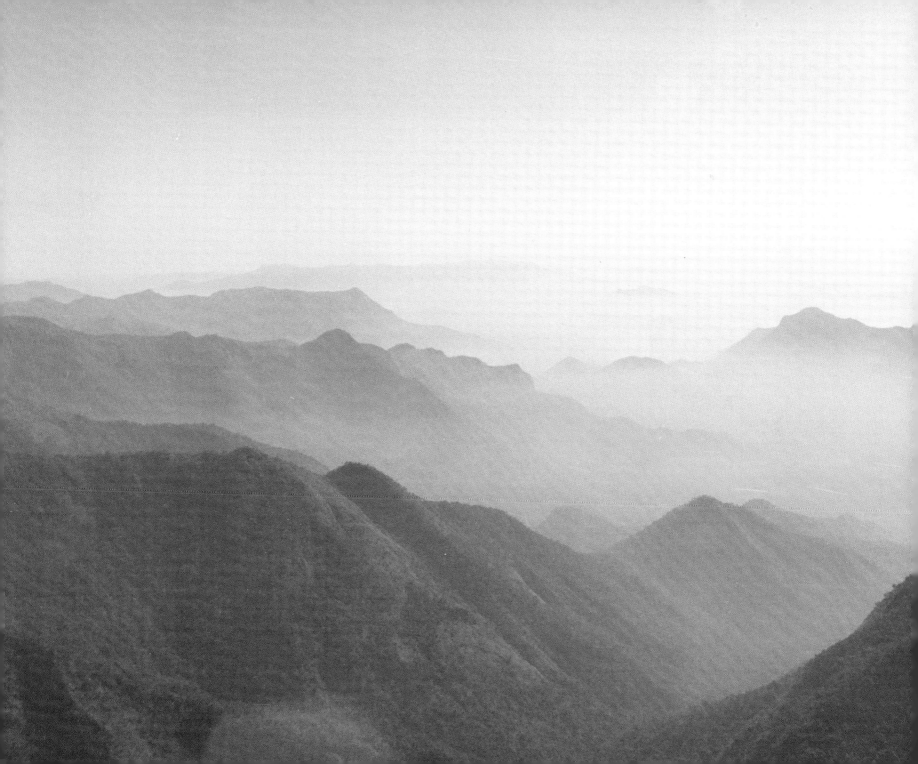

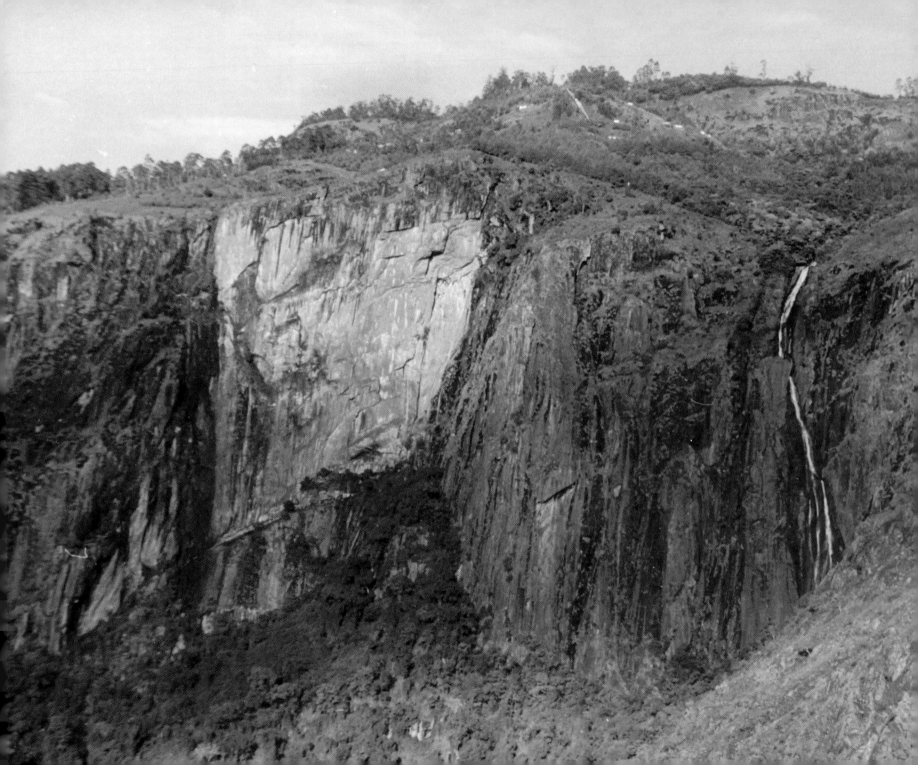

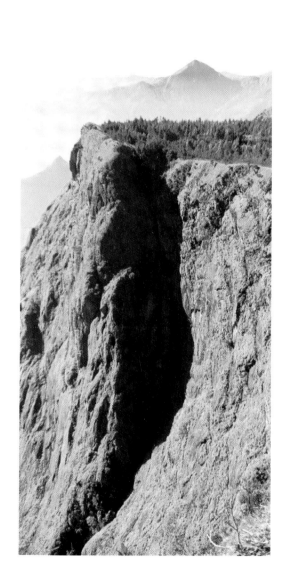 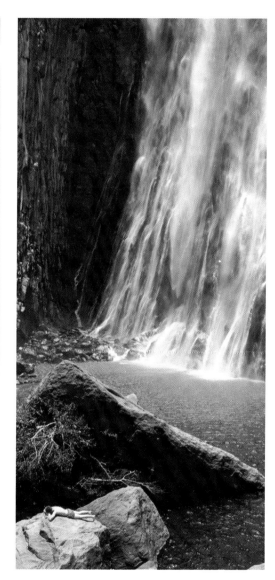

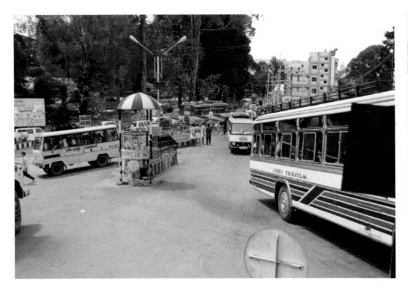
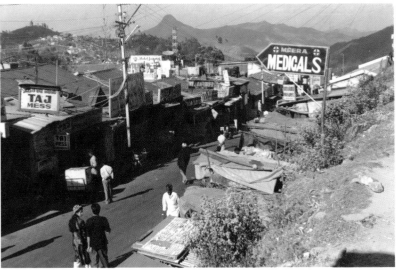
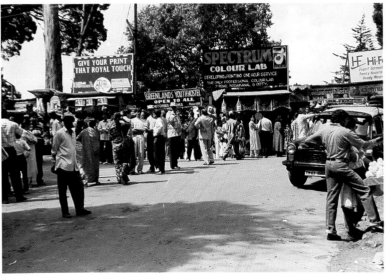

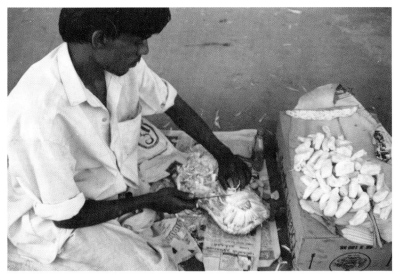

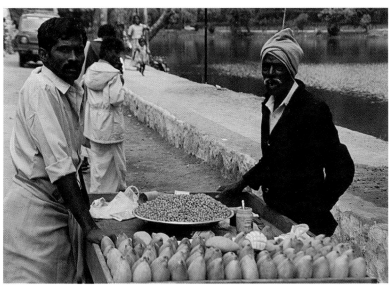

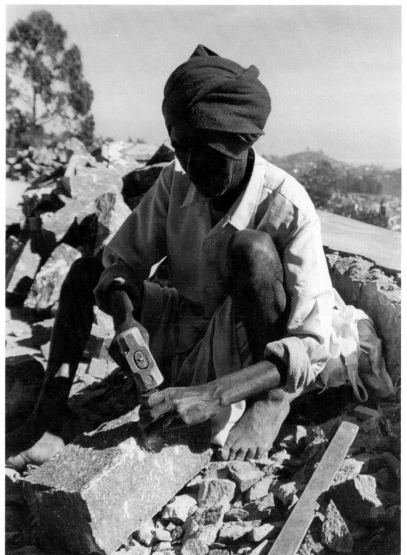

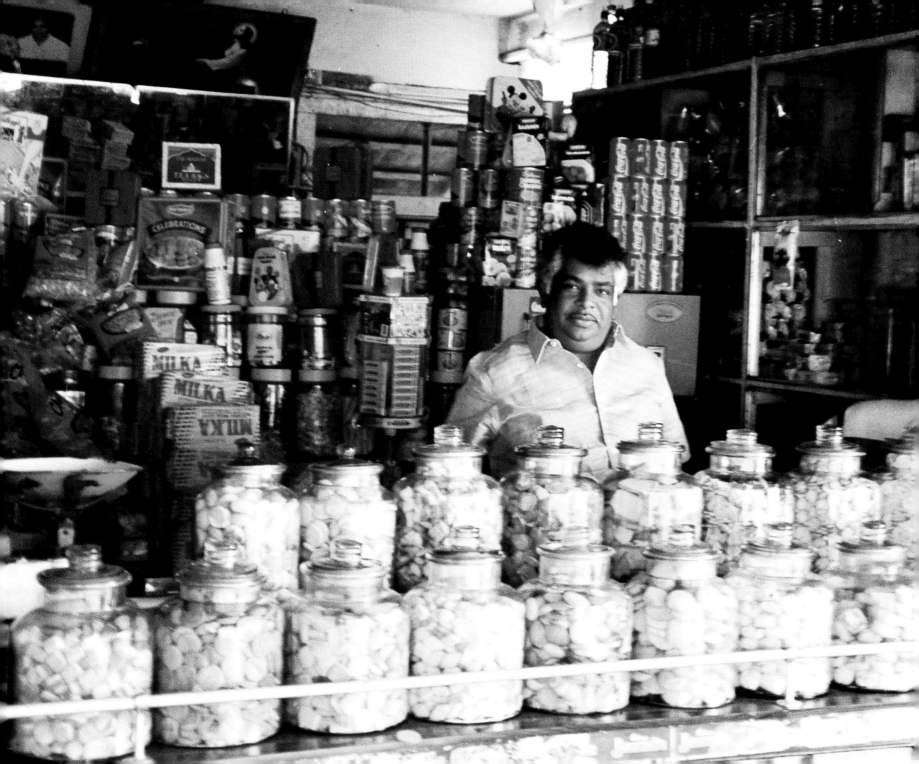

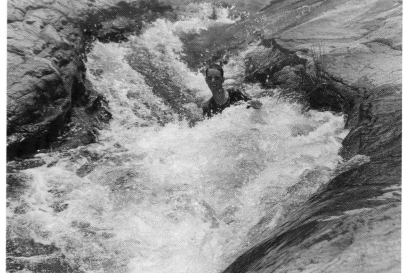

58

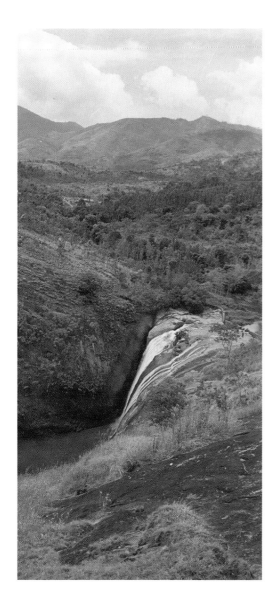

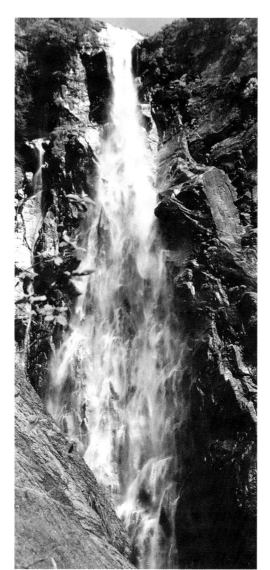

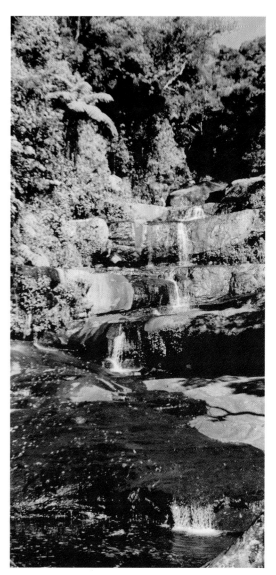

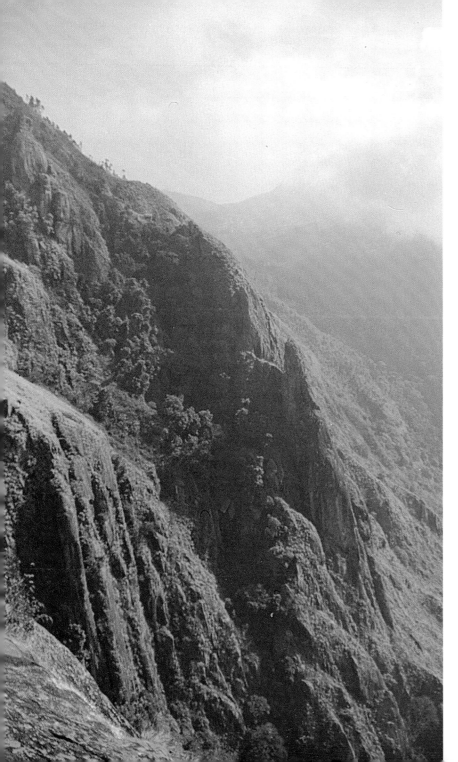
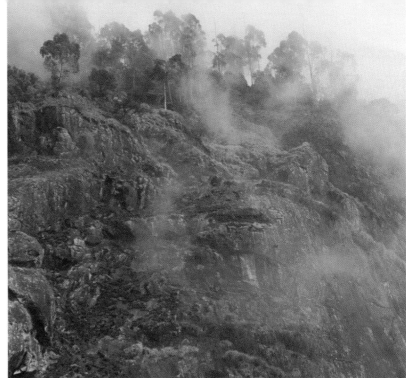
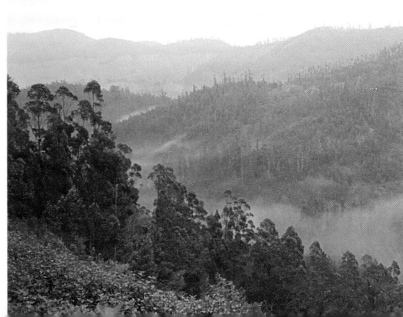

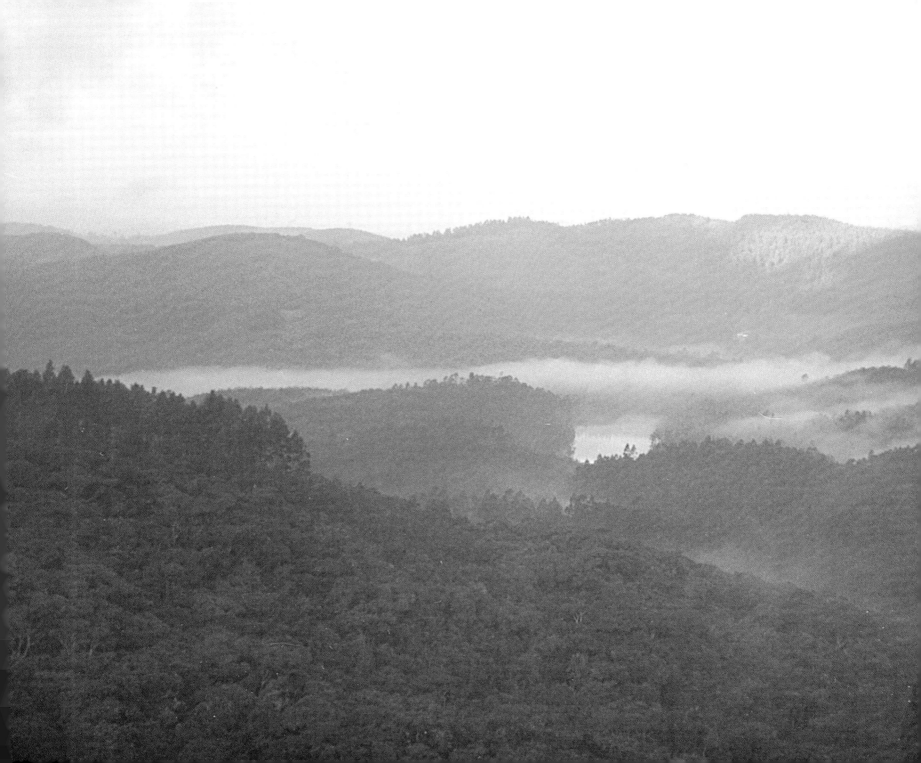

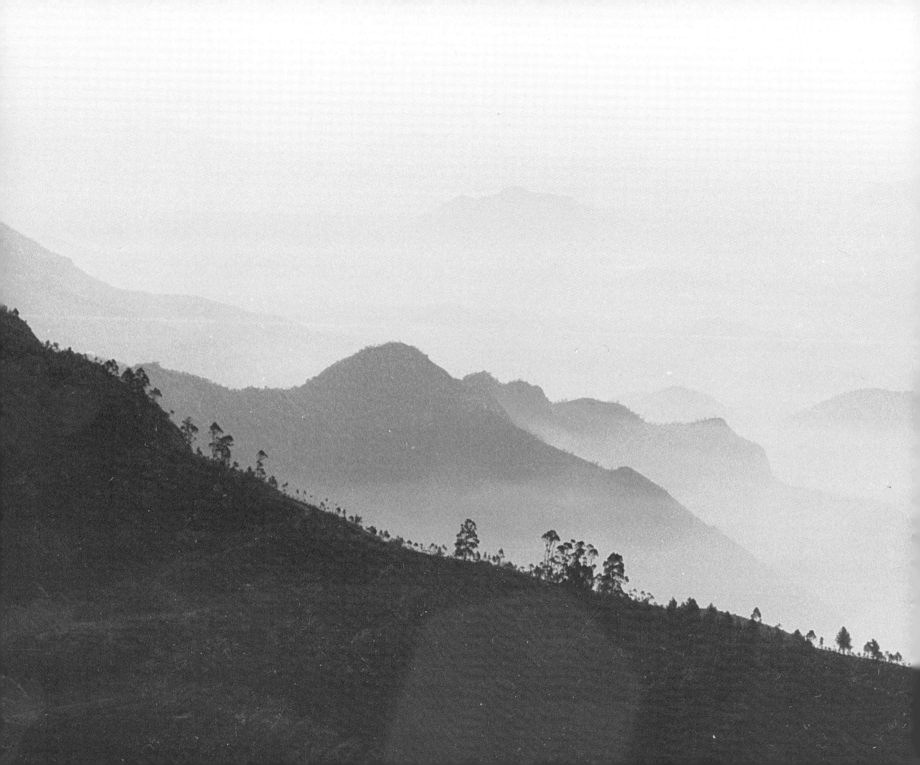

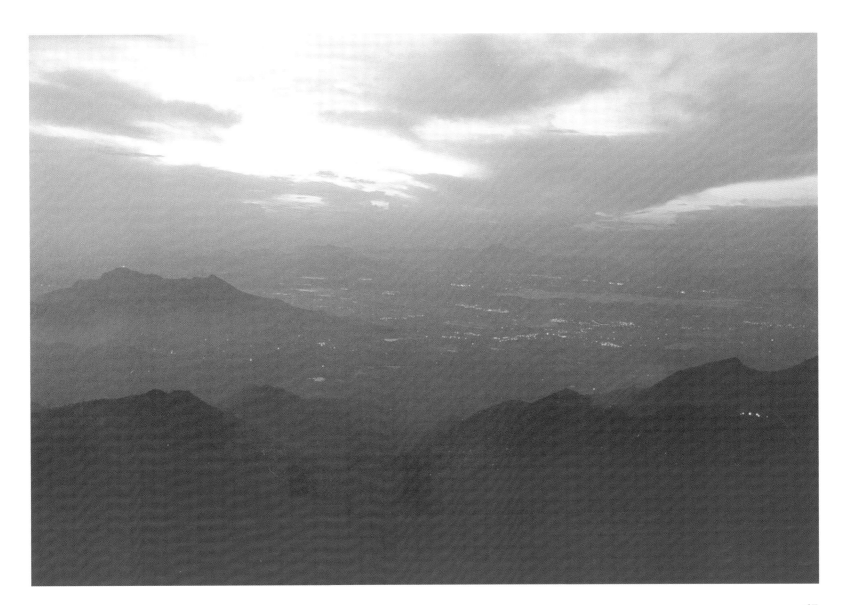

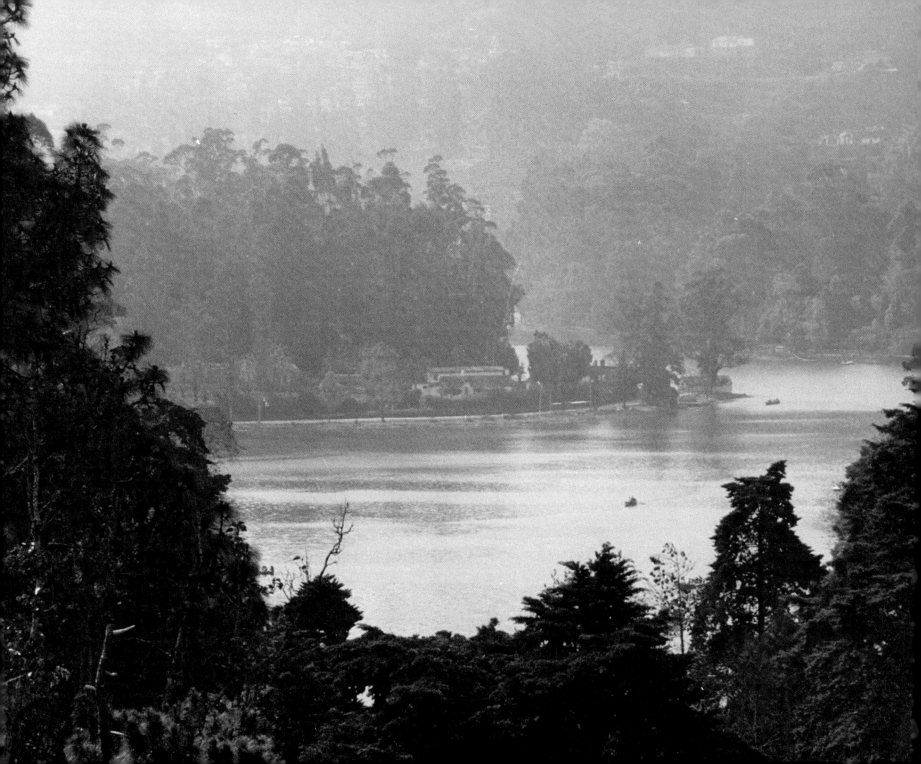

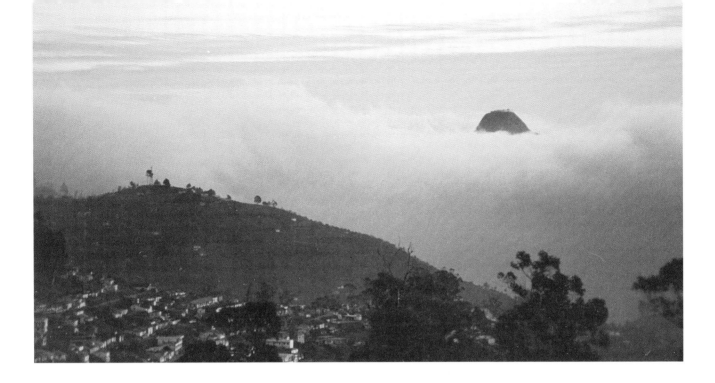

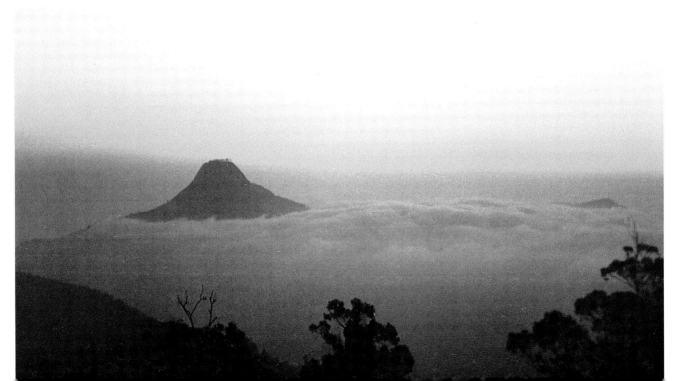

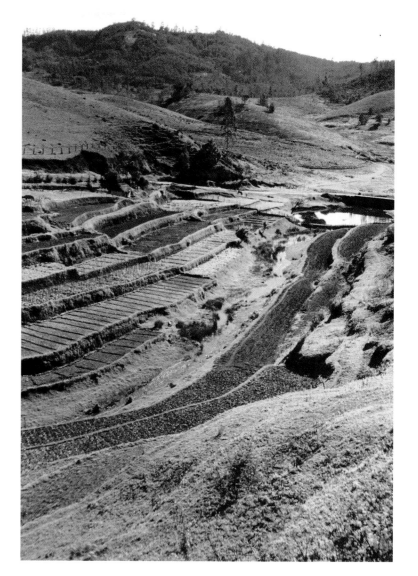

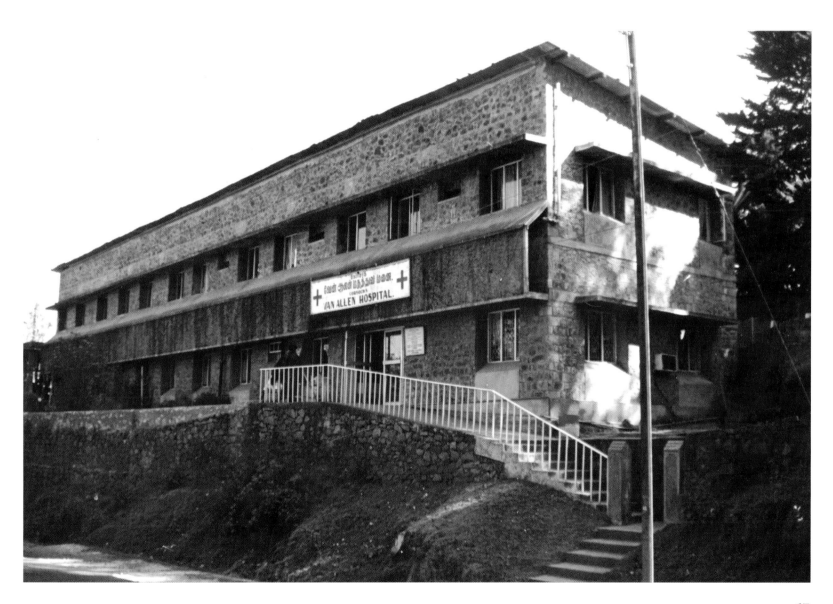

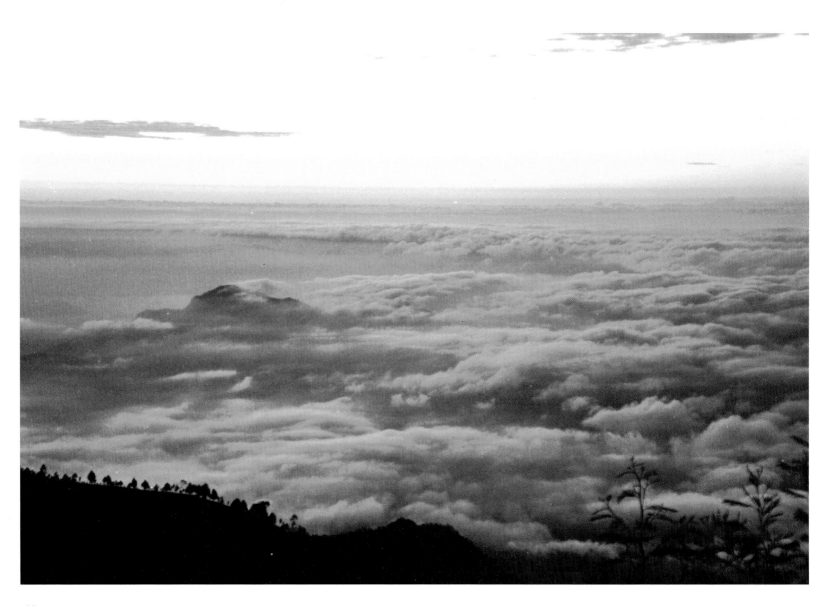

68

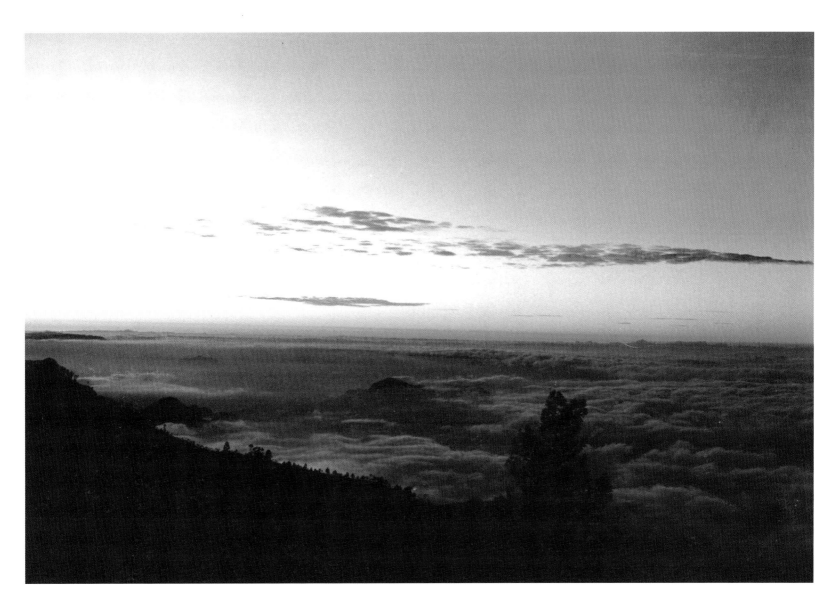